My Life
So far that is
II

James Willer PhD

Copyright © 2012 Author Name

All rights reserved.

ISBN:154491119x
ISBN-13:9781544911199

DEDICATION

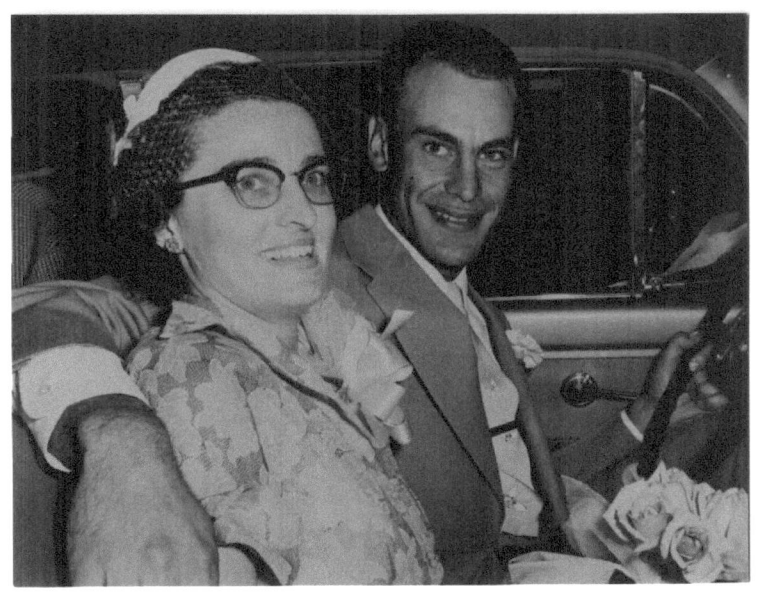

The start!

CONTENTS

This book is a collection of pictures I have taken over the years.

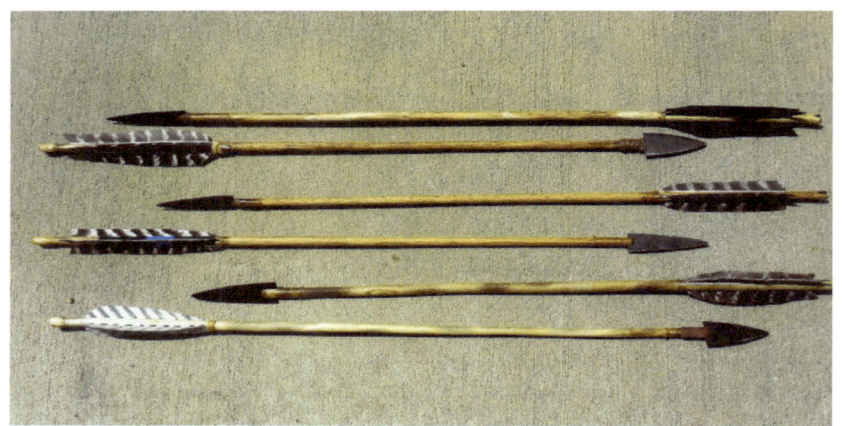

My Life

ACKNOWLEDGMENTS

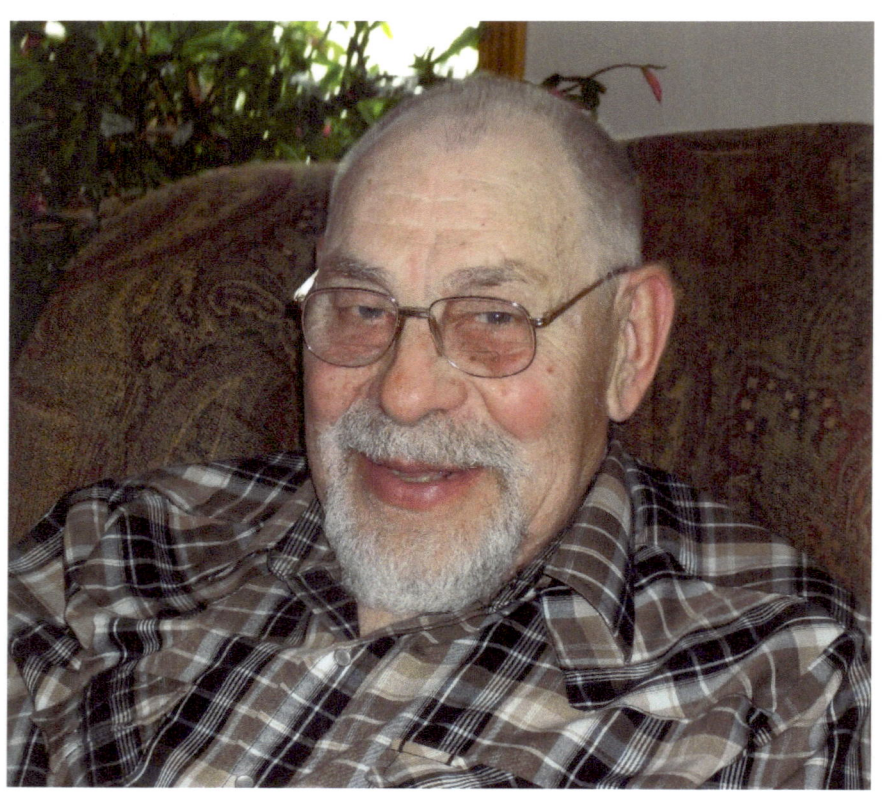

Chapter One

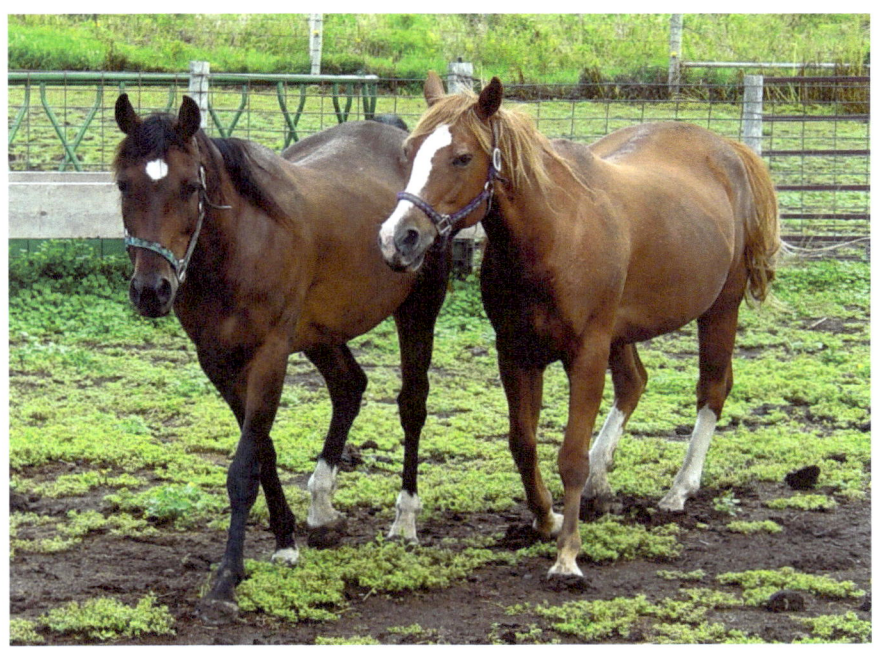

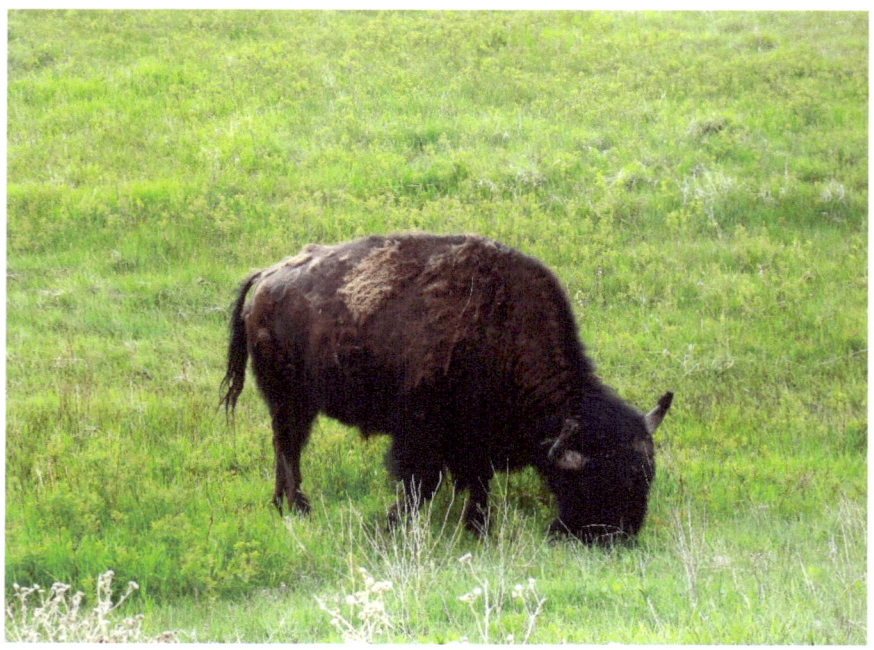

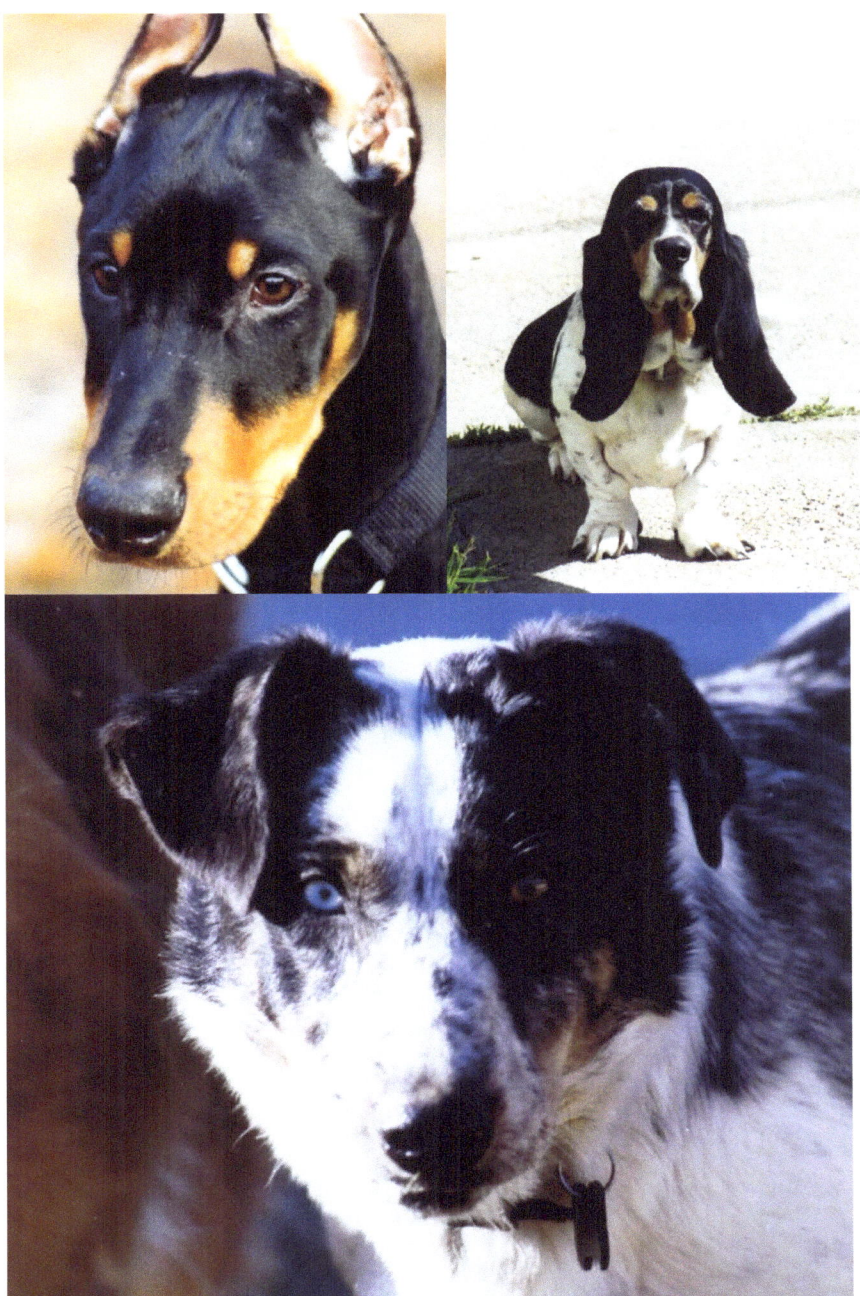

James Willer PhD

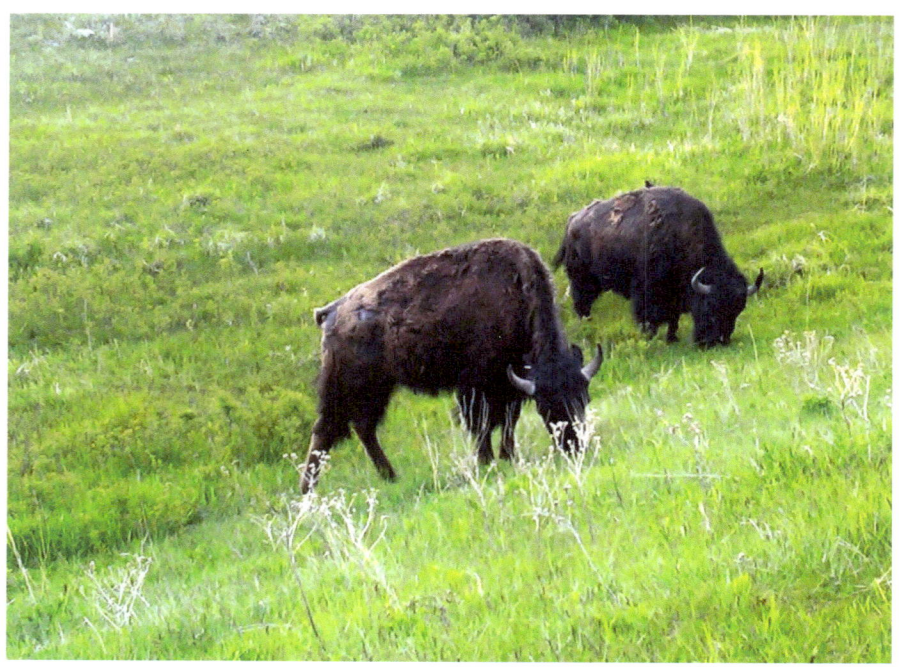

My Life

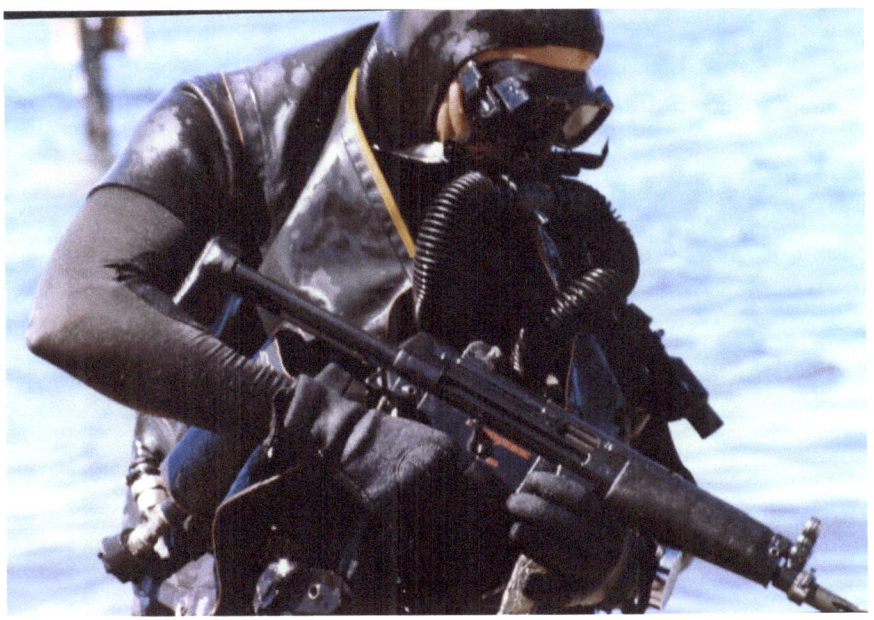

My Life

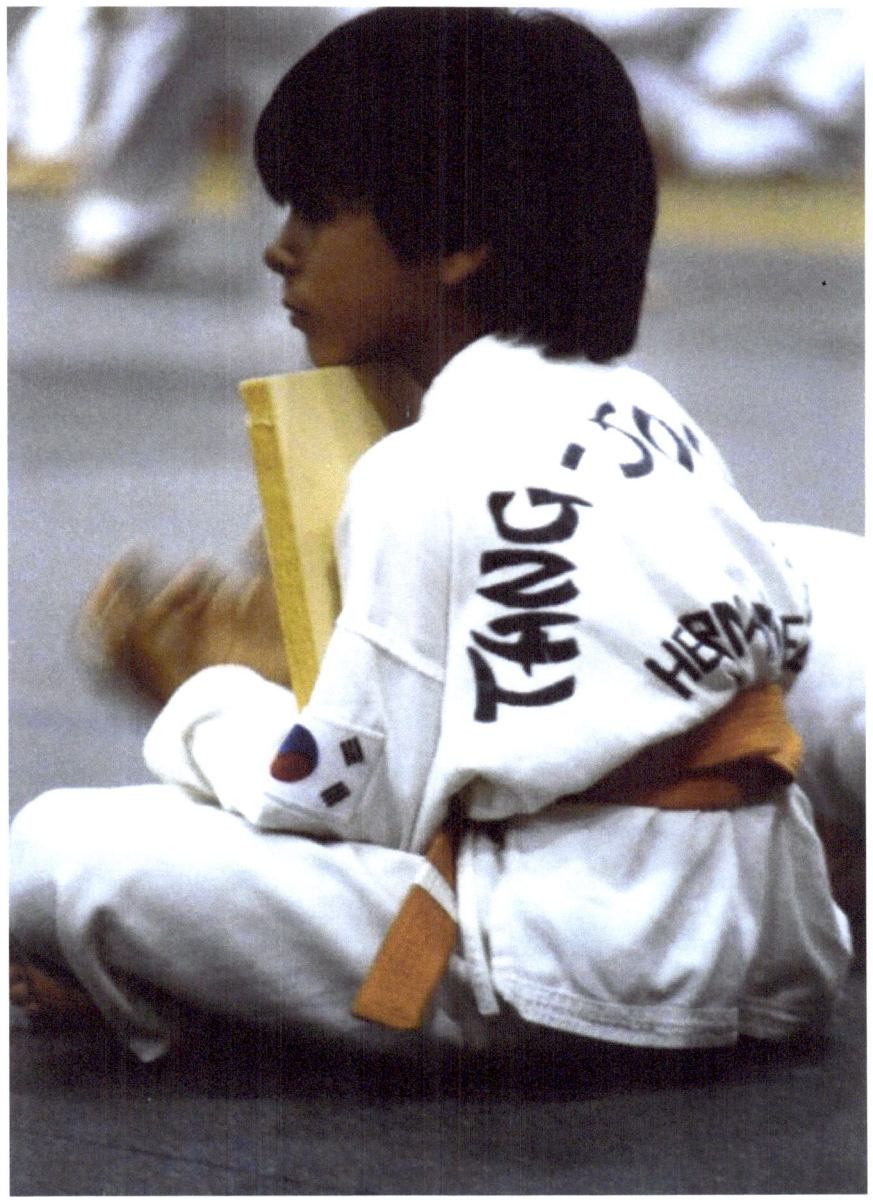

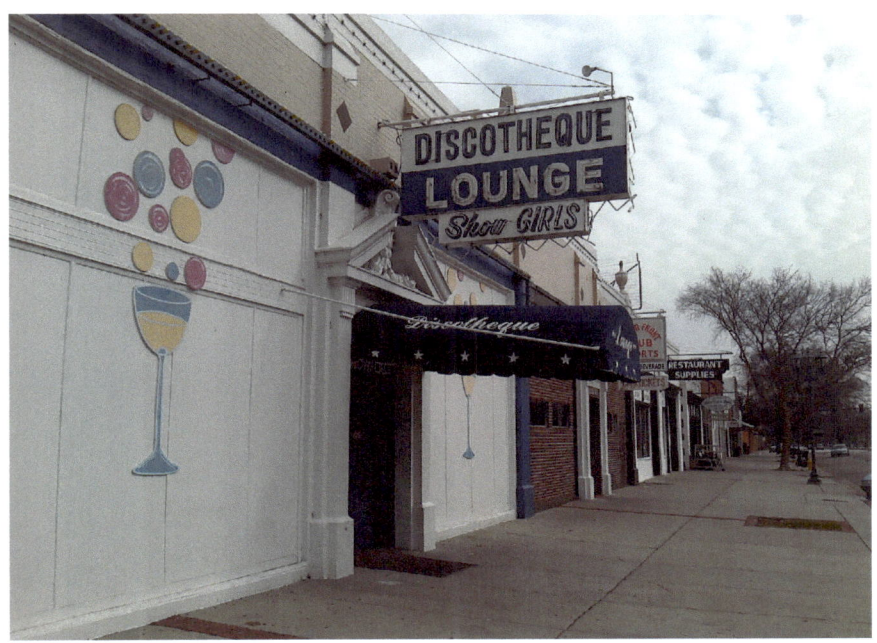

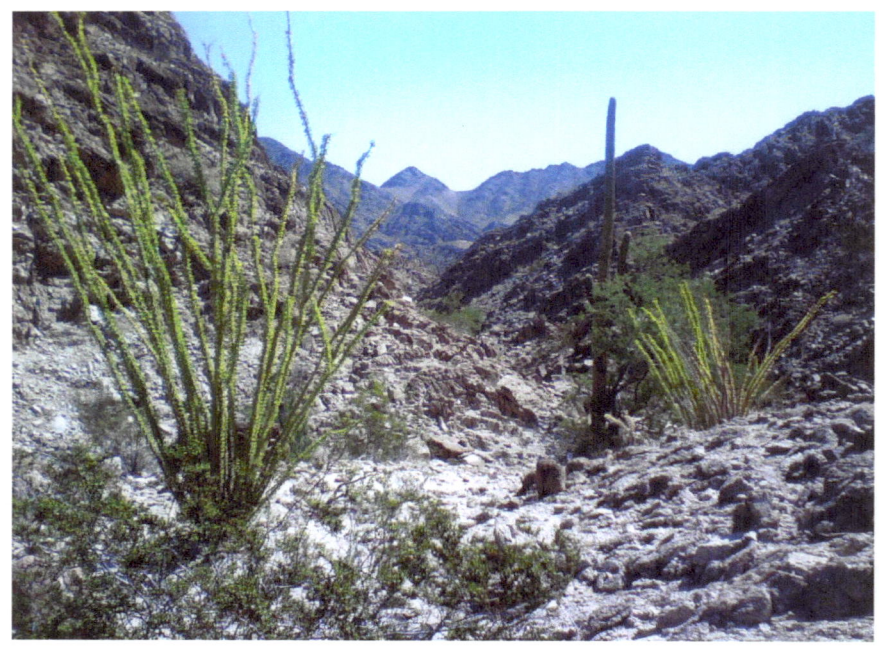

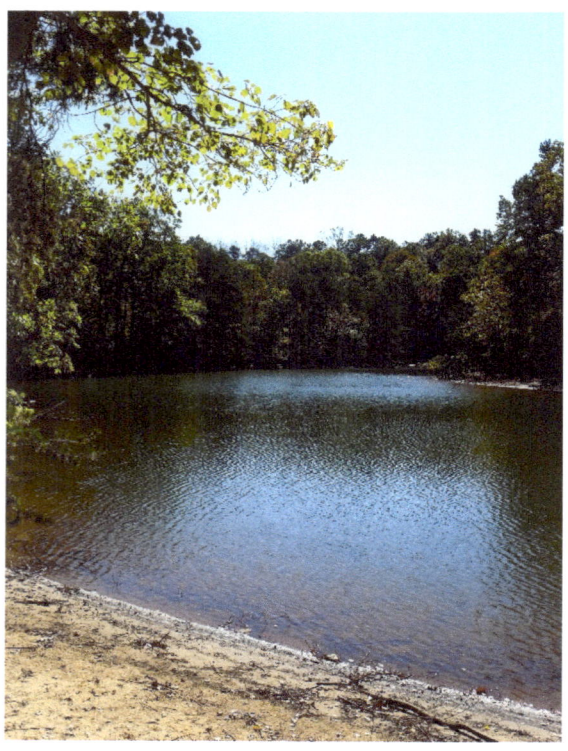

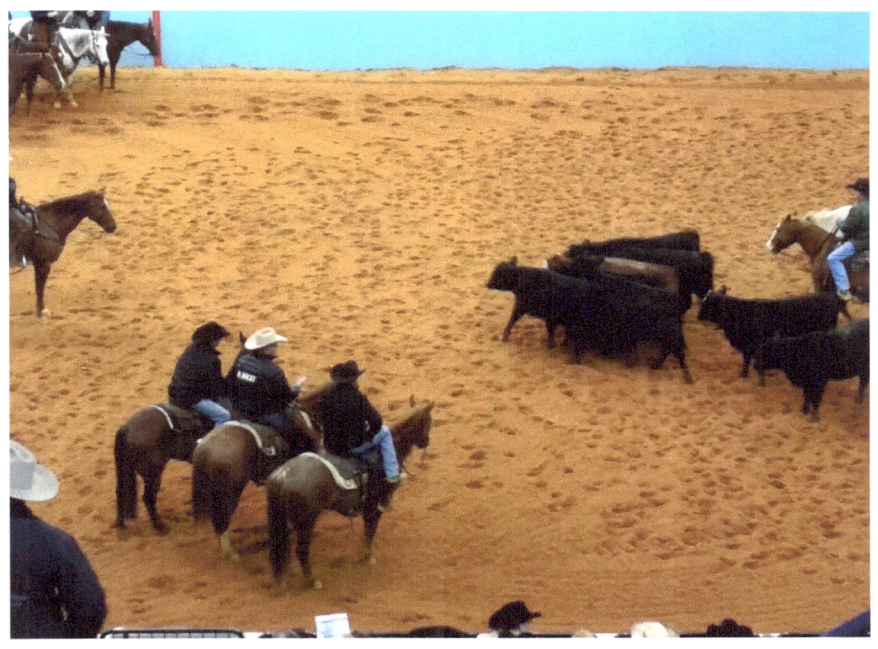

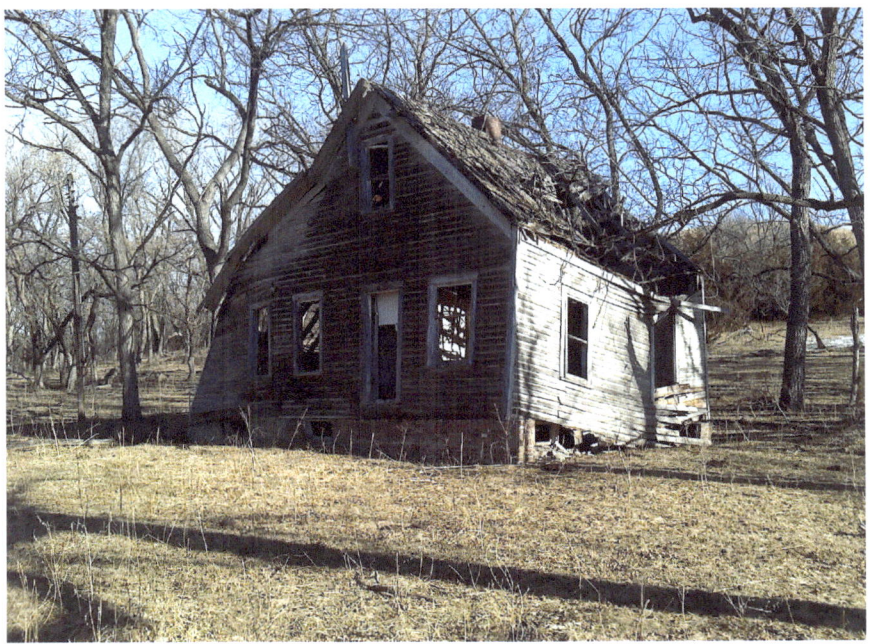

My Life

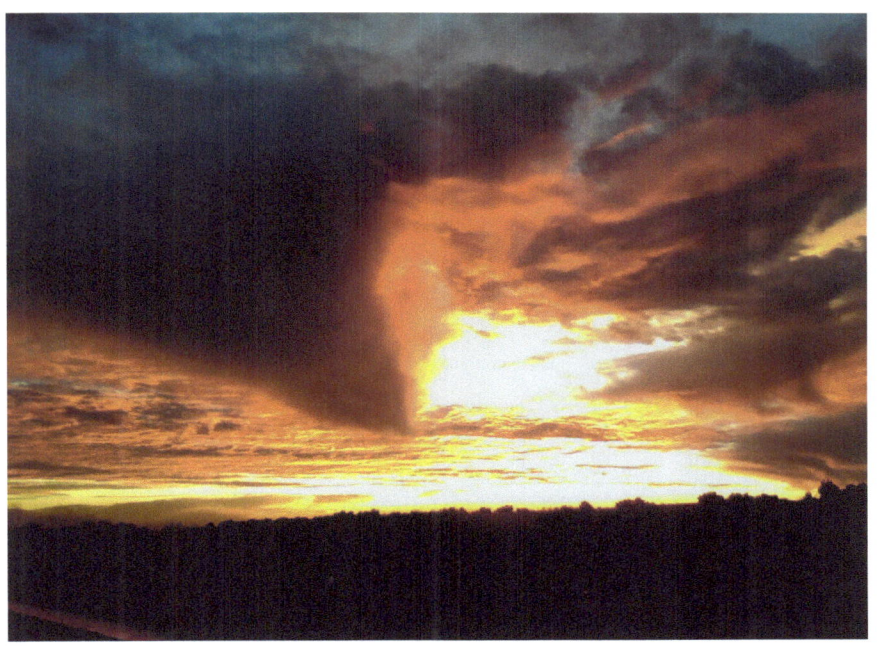

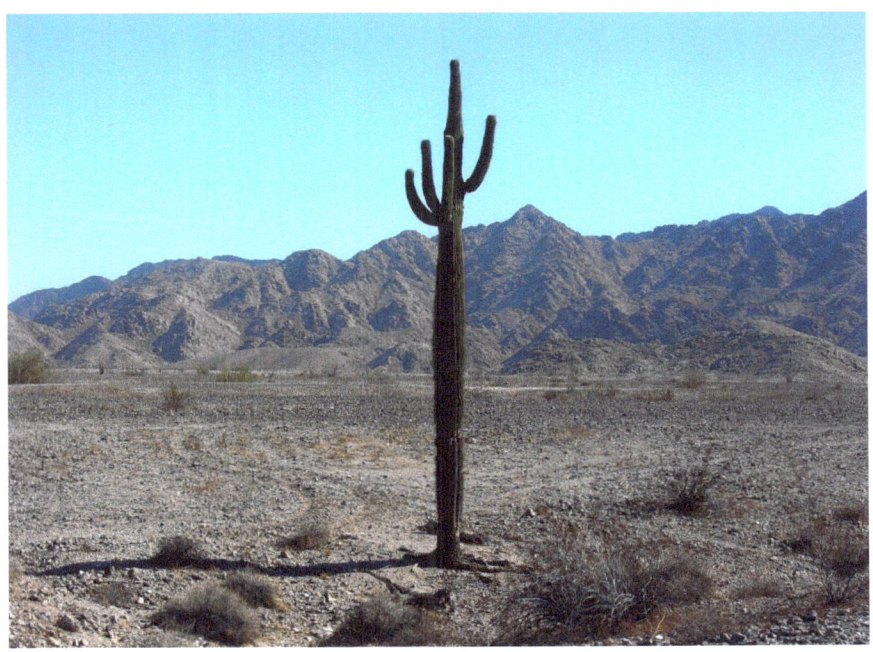

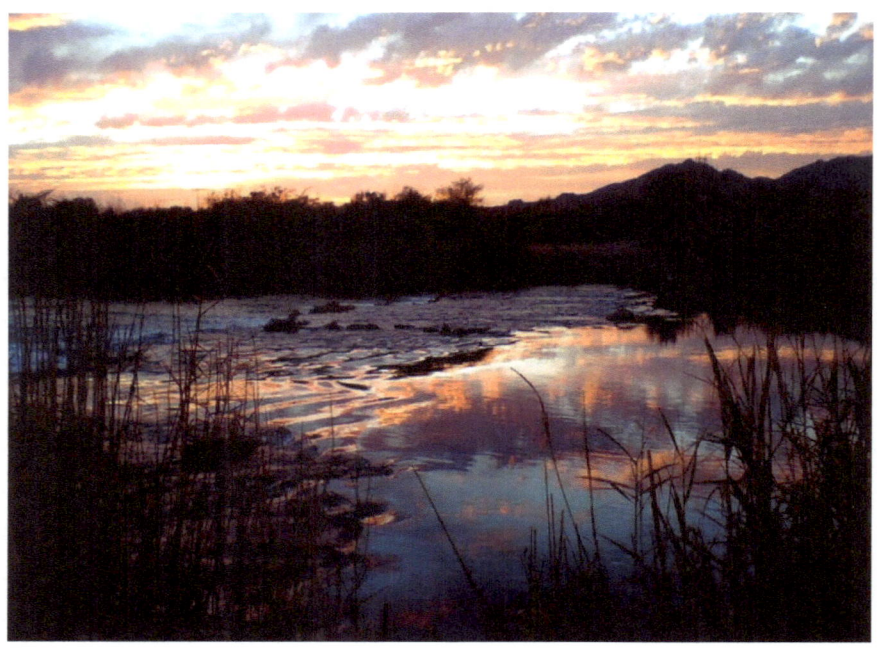

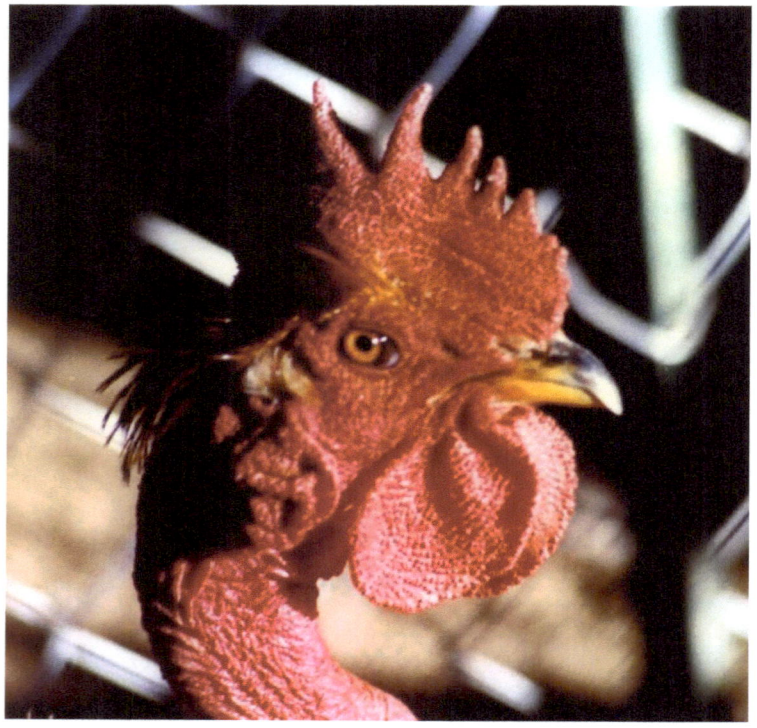

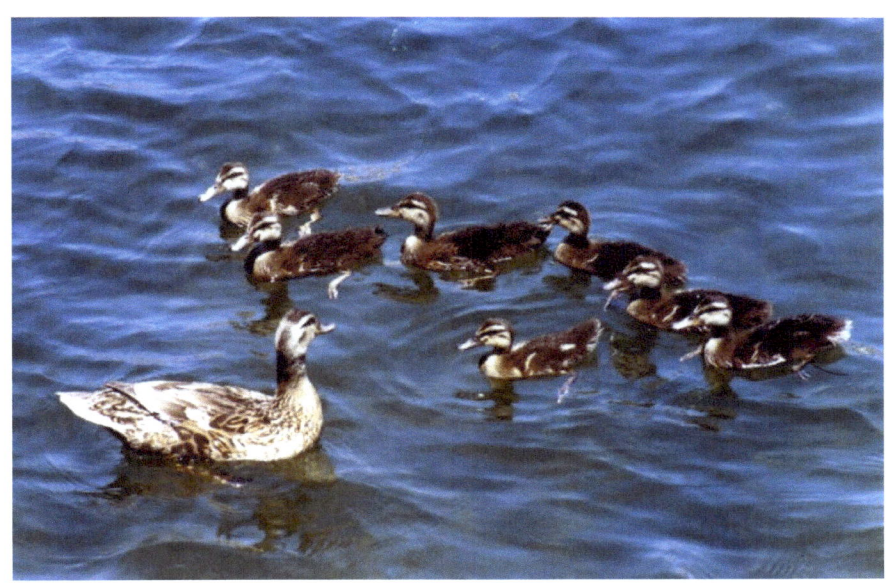

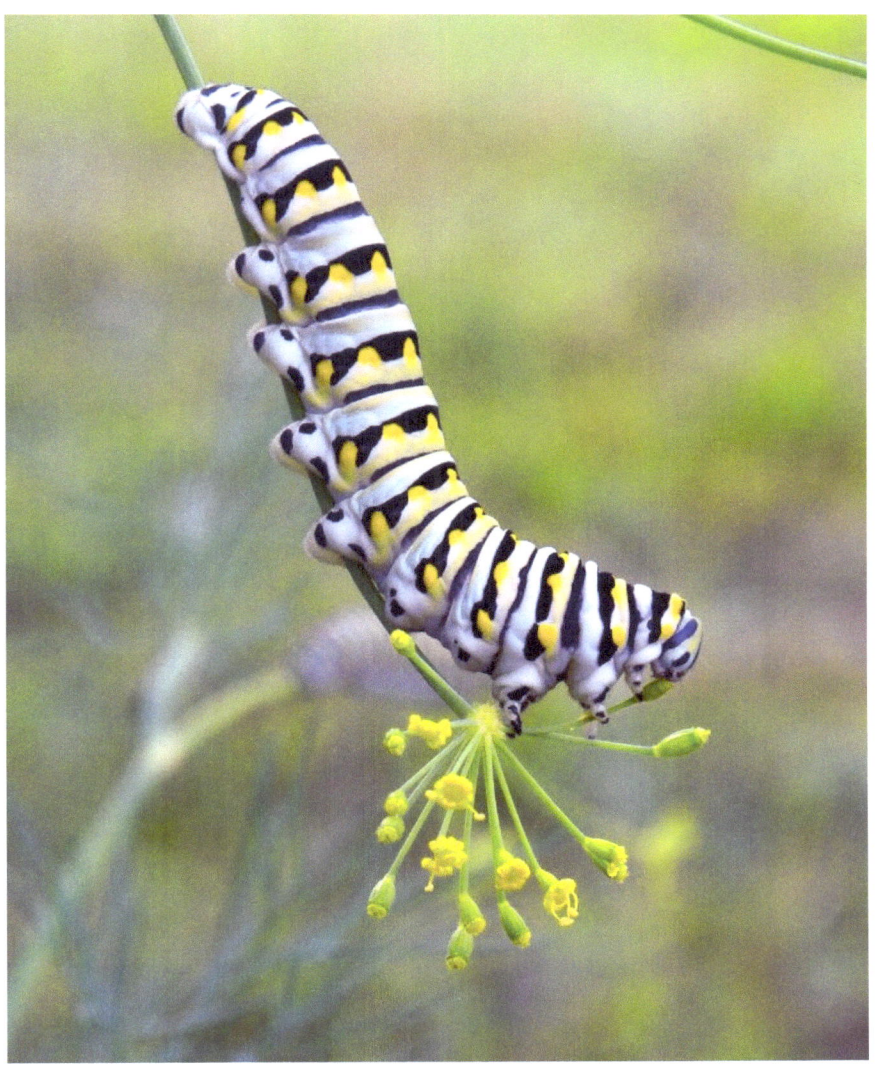

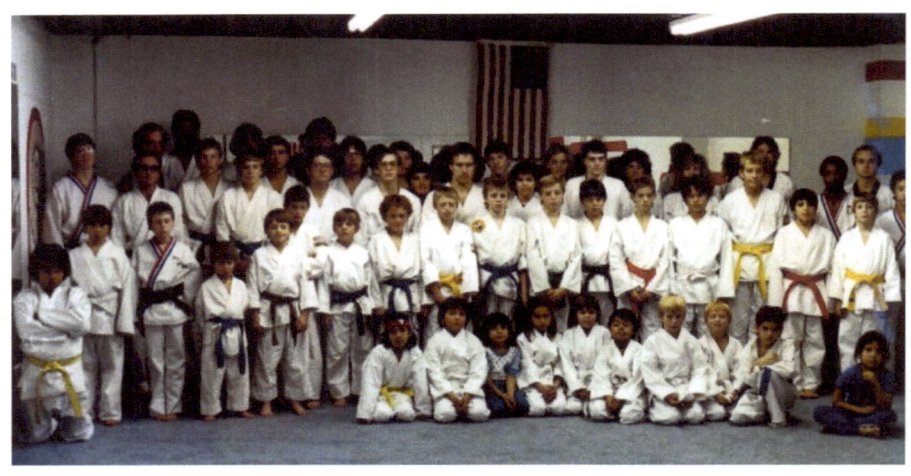
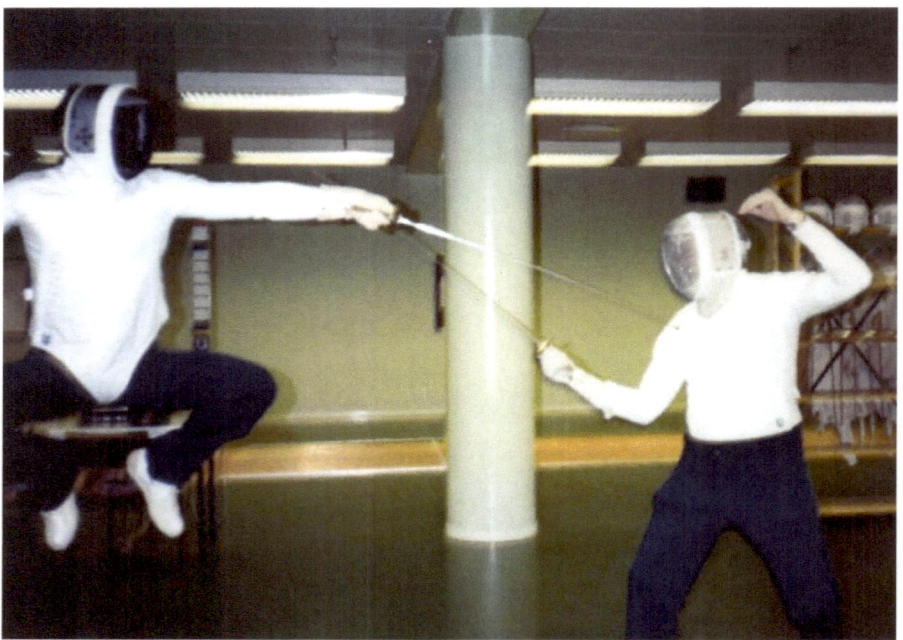

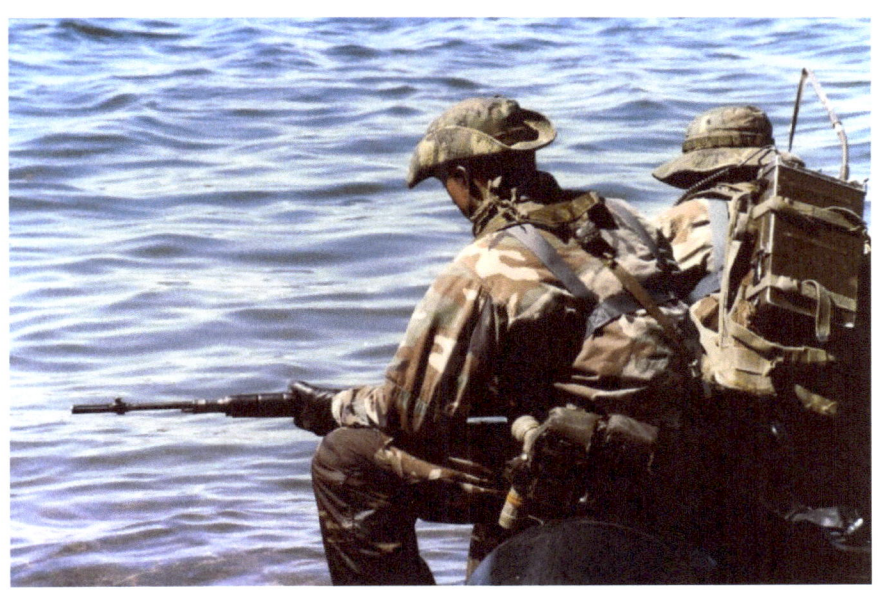

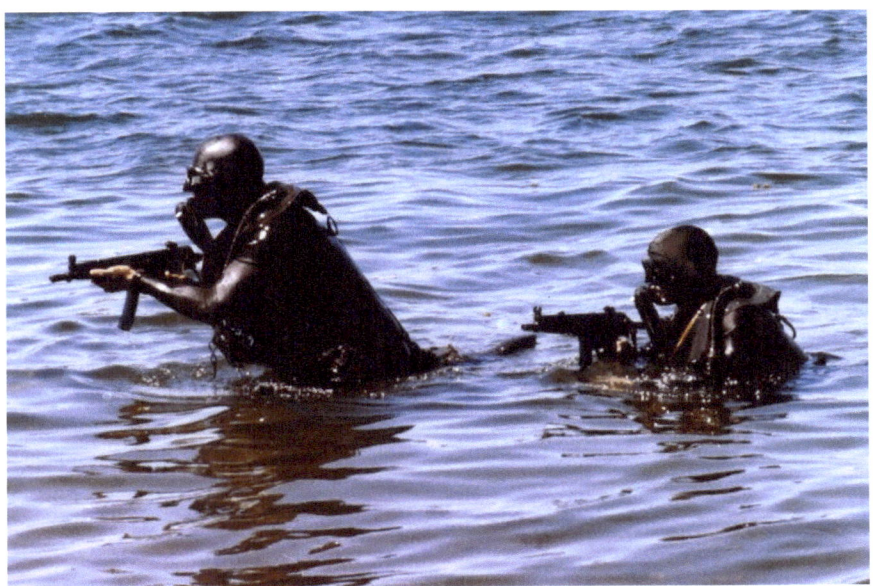

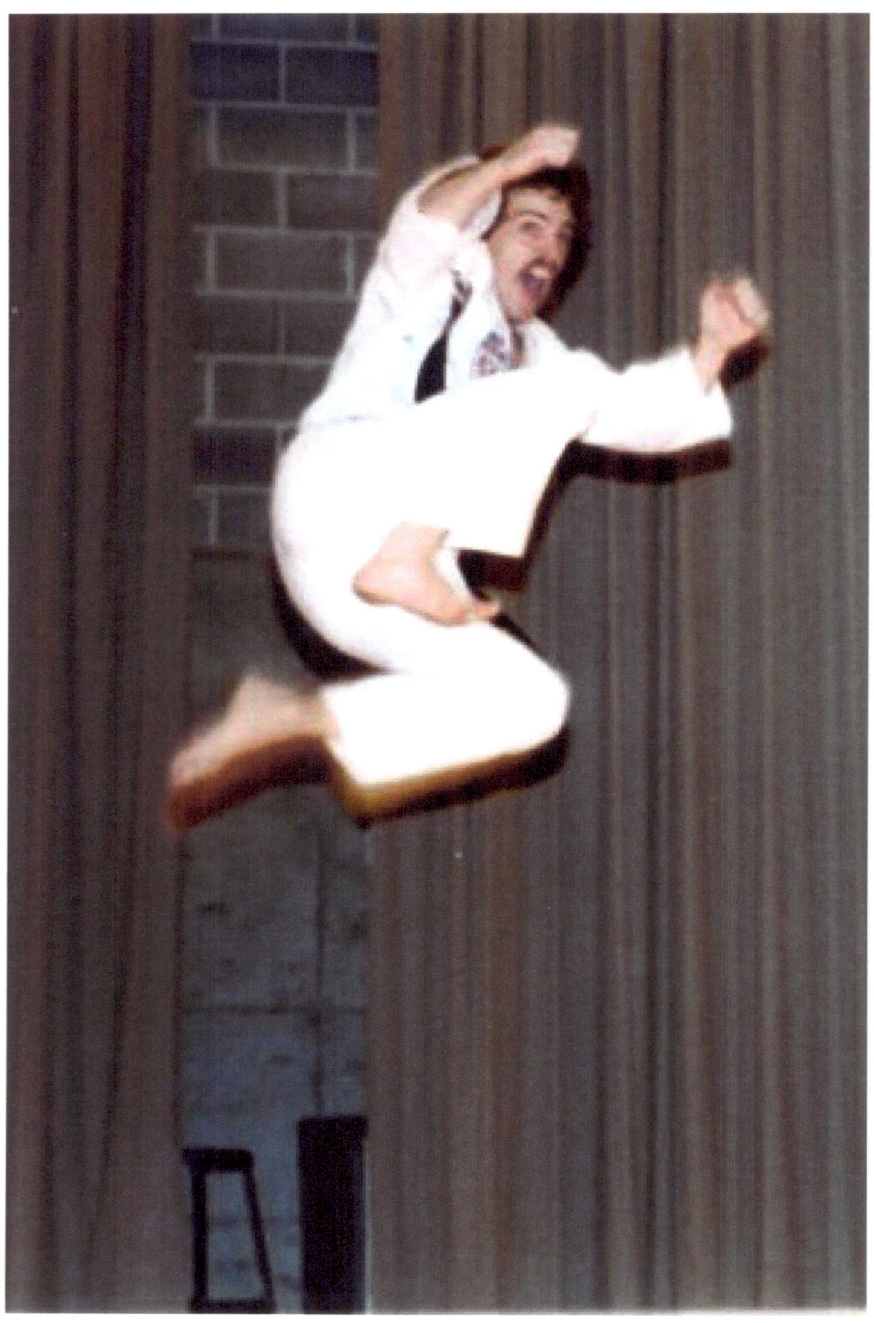

ABOUT THE AUTHOR

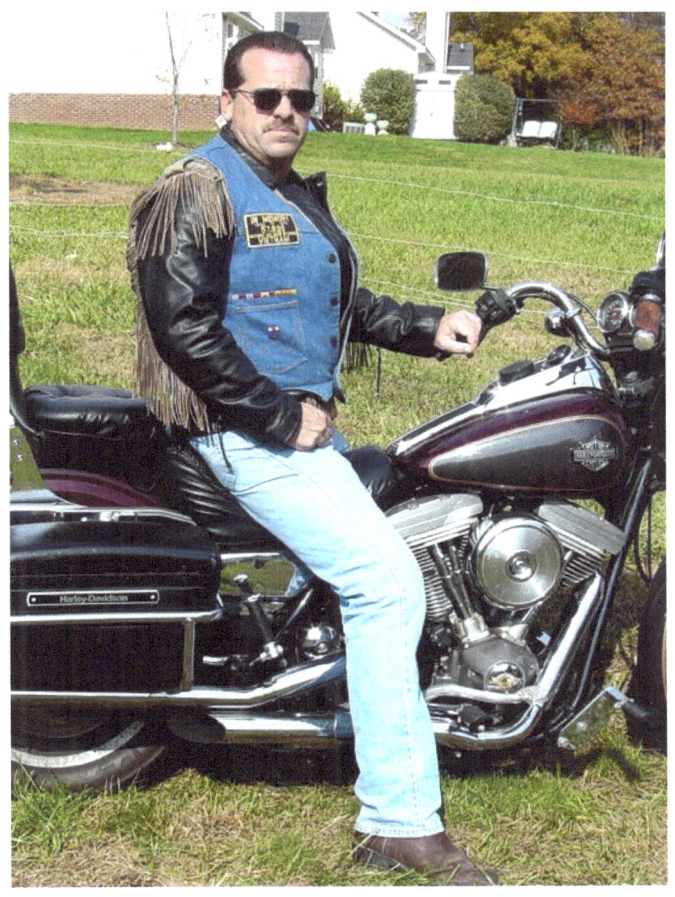

Active as a Black Belt founder of American Martial Arts, served over a dozen honorable years of military police service to America, and completed a new military based novel, boredom is not part of his lexicon. With more than 20 years of diverse medical experience, Dr. Willer worked for ECPI University as a medical instructor. He holds a doctorate in Healthcare Administration from Warren National University, masters from Wayne State College in education, and is a certified cardiovascular technologist. He is currently working as a Private Investigator in North Carolina.

www.ingramcontent.com/pod-product-compliance
Lightning Source LLC
Chambersburg PA
CBHW041113180526
45172CB00001B/231